Colour Mixing
Acryli

Julie Collins

Search Press

First published in 2016

Search Press Limited
Wellwood, North Farm Road,
Tunbridge Wells, Kent TN2 3DR

Reprinted 2018, 2020

ISBN: 978-1-78221-055-9

Suppliers
If you have difficulty in obtaining any of the
materials and equipment mentioned in this
book, then please visit the Search Press website
for details of suppliers: www.searchpress.com.
Always refer to your supplier's website or in store
for the latest ranges.

Acknowledgements

To Winsor & Newton for kindly
supplying the paints and other
materials used in this book.

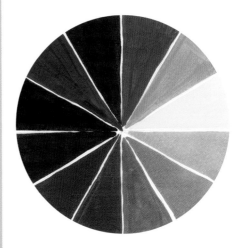

Contents

Introduction

Colour is one of the key ingredients of a successful painting. In this book I will teach you how to understand colour terminology, see colour, use it in context, and, most importantly, mix and combine colours. This will all help to increase your joy of colour.

During many years of teaching art, I have always found that students are inspired when they have learnt basic colour mixing. Immediately they begin to see huge possibilities in their painting and are amazed that this can be achieved with a limited palette and a little knowledge. If you want to be a successful painter, I believe you must learn colour mixing first.

This book includes various colour charts and can be used as a quick reference, but if you want to invest some time, you can use it as a guide to practising colour mixing. The more you practise, the more colour will become second nature, and you will then be able to paint more intuitively.

The book starts with primary, secondary and tertiary colours and the colour wheel. I use only thirteen colours and white, and show you how to create so much from them. We will take a look at complementary colours, warm and cool colours, dull and bright colours, colour tone and finally how to mix many yellows, oranges, reds, pinks, violets, blues, greens, browns, blacks and greys from our limited palette.

I always advise spending plenty of time mixing and testing colours before committing them to the 'real' painting, just as an athlete will always warm up and not just set off on a 100 metre sprint. This will save hours of frustration and disappointment.

Colour mixing is best approached with enjoyment as if you think of it as fun, you will achieve so much more.

Opposite:
Everness

Colours used: cadmium orange, titanium white, cerulean blue, burnt sienna, ultramarine blue and permanent rose. Mixes used: cerulean with white – dark, medium and pale; white with water – medium and pale; burnt sienna with ultramarine – a very dark mix (almost black), a medium and a pale mix; cadmium orange with a little ultramarine to dull it; permanent rose with water – medium and pale; and permanent rose and ultramarine to create a medium violet.

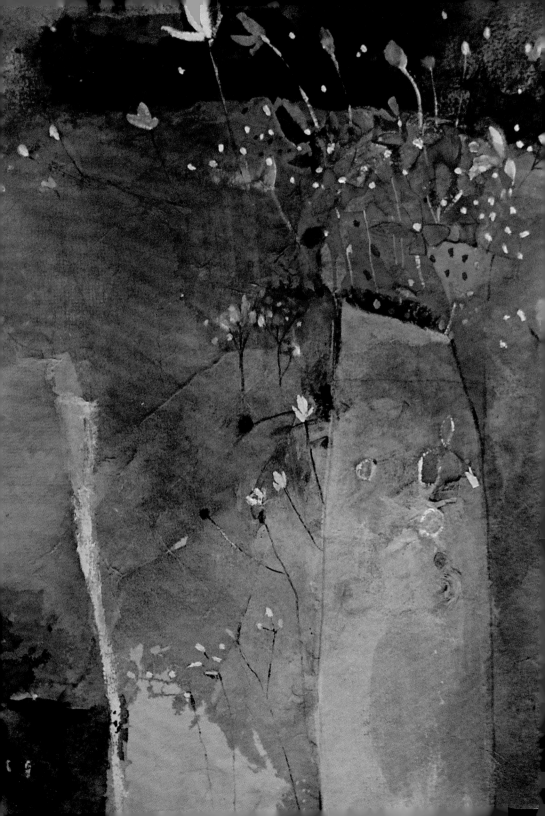

Materials

Paints

Acrylic is a synthetic resin paint. Acrylic paints are available in either tubes or large tubs. Tubs are more economical, but acrylic paint dries out in contact with the air, so tubes might last longer if you do not use large amounts.

The paints come in either artists' (professional) or students' ranges. I have used the professional range in this book, which is made from better quality pigments than the students' range. Therefore you will get better results with professional quality paint. The student's range is still extremely good and perfectly acceptable, particularly if you are a beginner.

Acrylic paints can be diluted or thinned by using either water or an acrylic medium or extender. This retains brushstrokes and is excellent for impasto effects. Acrylics dry quickly, allowing you to over paint and build up layers in your work much more quickly than when using oil paints. Acrylic has a thick, buttery consistency and the colours blend very easily and do not separate as you find with some watercolours.

Acrylic mediums and extenders

By adding an extender, you can literally extend the amount of paint you have. There are various acrylic mediums and these can alter the texture of your paint eg: gloss, matt, iridescent or heavy body.

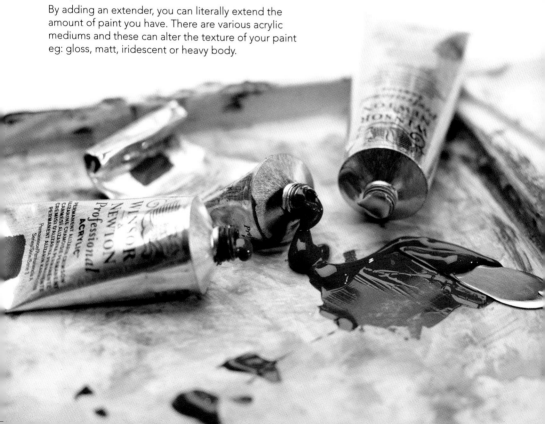

Brushes

Please use your old brushes for mixing paint, rather than wearing out your best ones. An old synthetic brush is just right for mixing. You may also use a palette knife for mixing acrylic paints, particularly if you are using thick paint straight from the tube and you are also going to be painting with a palette knife.

You can use either synthetic or bristle brushes for acrylic painting. These come in various sizes and styles including: long or short handled and the following shapes: round, flat or filbert.

If you care for your brushes, they will last a lot longer. The worst thing you can do is to leave a brush standing in your water jar. This bad habit will ruin the point of your brush in no time and once the point has gone, you won't be able to paint well with it. Take time to clean and store your brushes properly.

As a general rule you get what you pay for and if you are a keen painter, it is worth investing in good brushes. I use several types for acrylic painting: good synthetic brushes and various bristle brushes.

Surfaces

There are numerous choices when it comes to surfaces suitable for acrylic painting and these include:

Canvas This can be cotton or linen, and it needs to be stretched and primed before use, or you can buy ready prepared and primed canvases in any size.

Canvas boards Canvas already prepared on a board, ready for use.

Acrylic sheets, pads and blocks These are sheets of textured paper ready to paint on.

Watercolour paper It is fine to use watercolour paper for your acrylic painting, whether you are using your acrylic like watercolour or painting thickly.

Wooden panels These need to be prepared but can provide an excellent surface to work on.

Palettes

There is a lot of choice when it comes to palettes for acrylic painting and these include:

Disposable palettes These come in tear-off pads.

Wooden palettes

Glass palettes

Transparent acrylic palettes These are made from clear acrylic and can be used with acrylic paints.

Stay-wet palettes These have an absorbent layer to which you add water to keep your acrylics wet for longer.

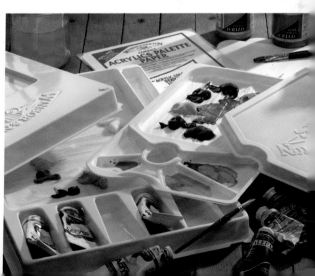

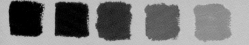

Colours used in this book

There are only thirteen colours used in this book and they are briefly explained and illustrated here, going from dark to light.

Red iron oxide is an opaque red with blue undertone. It is particularly useful in landscape painting and can be used to make subtle purples.

Burnt sienna is a rich brown pigment made by burning raw sienna. It has red-brown tones and is one of the two most useful colours in my palette. It is essential in landscape painting and is used to make wonderful greys.

Raw sienna is a bright yellow-brown pigment, also essential in landscape painting. It is one of the oldest pigments and can be found in prehistoric cave art.

Lemon yellow is a very clear, bright yellow and is part of the Hansa pigments which were discovered in Germany in the early 1900s. It can be used to mix amazing lime greens.

Cadmium yellow medium is a warm, opaque, mid-range single-pigment yellow. It is a very useful mid-yellow to include in your palette.

Cadmium orange is an opaque, single-pigment orange with a high tinting strength. It is an essential colour as it is not possible to mix an orange like this.

Cadmium red medium is a warm mid-red and a single-pigment colour. It is a highly stable, bold opaque red. It is very useful in flower painting and also for mixing oranges and pinks.

Permanent rose is a transparent, bright rose-violet, made from a quinacridone pigment. It is essential in your palette for flower painting.

Permanent alizarin crimson is a highly transparent colour and a vivid red with a blue undertone. It is very useful in both flower and landscape painting.

Dioxazine purple is a vivid mid-shade purple, made from a transparent coal tar pigment. When undiluted, it can be used as a deep black. It is essential in the flower painter's palette and good for mixing dark colours.

Cobalt blue is a clean, fresh blue. It is very useful for painting skies and landscapes and for mixing greys.

Ultramarine blue is a rich, bright blue and is the other most useful colour in my palette. Like cobalt blue, it is essential for lanscapes and skies and for mixing greys.

Phthalo blue (red shade) is a deep, intense blue with a red undertone. It is made from a modern pigment, phthalocyanine.

The colour wheel

The colour wheel is essential to understanding colour mixing and using colour. Making your own colour wheel will teach you how to quickly mix tertiary colours and this will lead into the exciting world of colour mixing and you will no longer feel limited to primary colours.

1 Set up your palette and materials and then draw your template on to the watercolour paper.

2 First, paint the three primary colours – be careful to keep the tone of each colour as similar as possible and clean your brush thoroughly when you move on to a new colour. Paint yellow at 12 o'clock, red at 4 o'clock and blue at 8 o'clock.

3 Next, paint the three secondary colours: orange at 2 o'clock, violet at 6 o'clock and green at 10 o'clock.

4 Last, mix the six tertiary colours: yellow-orange at 1 o'clock, red-orange at 3 o'clock, red-violet at 5 o'clock, blue-violet at 7 o'clock, blue-green at 9 o'clock and yellow-green at 11 o'clock.

Materials

Paints:

Cadmium red medium

Ultramarine blue

Cadmium yellow medium

Palette

Round brushes, sizes 6 & 2

A4 watercolour paper, Not surface, 425gsm (200lb) weight

Test paper

Two water jars

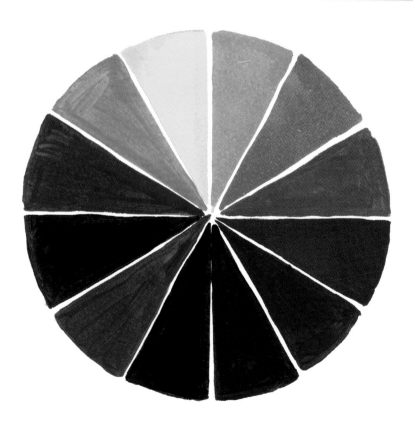

Note

Further information about the primary, secondary and tertiary colours can be found on pages 12–15.

Template

Transfer this template on to watercolour paper to create your own colour wheel.

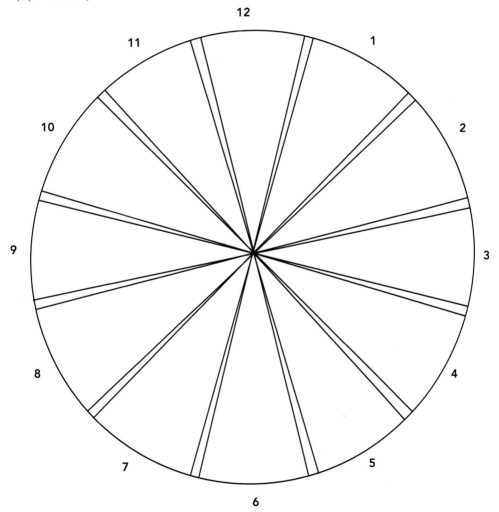

Primary colours

There is a lot to be read about the theory of colour but for the purpose of this book, I want to keep it as accessible as possible. Red, yellow and blue are the primary colours and you can mix a useful set of colours from these. These are primaries because you must have them to start with, as you cannot mix them.

Here are swatches of two blues, two yellows and two reds that are used in this book. Try making the exact tone of each primary colour swatch. This will be good practice for your colour mixing later on, as you will begin to think about tone and become aware of the amount of water or white paint you are adding from the word go.

Begin by noticing the difference between the two blues, two yellows and two reds.

Blues

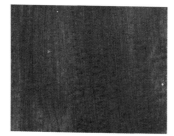

Ultramarine blue

Phthalo blue (red shade)

Yellows

Cadmium yellow medium

Lemon yellow

Reds

Cadmium red medium

Permanent alizarin crimson

Secondary colours

Secondary colours are made from mixing one primary with another in equal amounts, eg, red and yellow = orange. This is fully illustrated here and can also be seen in context on the colour wheel.

Greens

Ultramarine blue + cadmium yellow medium

Ultramarine blue + lemon yellow

Oranges

Cadmium red medium + cadmium yellow medium

Cadmium red medium + lemon yellow

Browns

Cadmium red medium + phthalo blue (red shade)

Cadmium red medium + ultramarine blue

Teritiary colours

Tertiary colours are created by mixing a primary colour with an adjacent secondary colour or by mixing two secondary colours together.

The tertiary colours are:

Red-violet, red-orange, yellow-orange, yellow-green, blue-violet and blue-green. The chart below and right illustrates two of each of the tertiary colours and explains the colours used in each mix.

Yellow-orange

Cadmium yellow medium + (cadmium yellow medium + cadmium red medium)

Red-orange

Cadmium red medium + (cadmium yellow medium + cadmium red medium)

Red-violet

Cadmium red medium + (cadmium red medium + ultramarine blue)

Blue-violet

Ultramarine blue + (ultramarine blue + cadmium red)

Blue-green

Ultramarine blue + (ultramarine blue + cadmium yellow medium)

Yellow-green

Cadmium yellow medium + (cadmium yellow medium + ultramarine blue)

Yellow-orange

Lemon yellow + (lemon yellow +
cadmium red medium)

Red-orange

Cadmium red medium + (cadmium
red medium + lemon yellow)

Red-violet

Cadmium red medium + (cadmium
red medium + phthalo blue red shade)

Blue-violet

Phthalo blue red shade + (phthalo blue
red shade + cadmium red medium)

Blue-green

Phthalo blue red shade + (phthalo
blue red shade + lemon yellow)

Green-blue

Lemon yellow + (lemon yellow +
phthalo blue red shade)

Complementary colours

When complementary colours are placed next to each other they create the strongest contrast and enhance each other. The most common examples are:

Green with red Orange with blue Yellow with violet

The easiest way to see this is to see examples, as painted below. Note how the ultramarine blue reinforces an orange, or, in other words, how they literally complement each other.

Blue: cobalt blue

Pink: permanent rose

Green: cobalt blue + cadmium yellow medium

Orange: permanent rose + lemon yellow

Purple: permanent alizarin crimson + cobalt blue

Yellow: lemon yellow

Orange: cadmium orange

Purple: dioxazine purple

Try practising by experimenting with the colours you have and mixing your own sets of complementary colours.

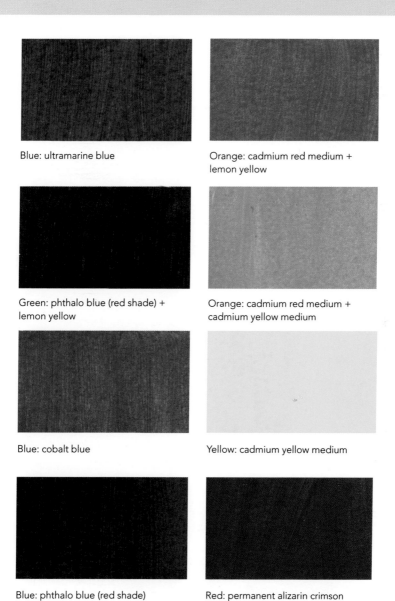

Blue: ultramarine blue

Orange: cadmium red medium + lemon yellow

Green: phthalo blue (red shade) + lemon yellow

Orange: cadmium red medium + cadmium yellow medium

Blue: cobalt blue

Yellow: cadmium yellow medium

Blue: phthalo blue (red shade)

Red: permanent alizarin crimson

Warm and cool colours

Warm colours include reds, oranges and yellows and cool colours include blues, violets and greens. However, when you consider colour more closely, there are also cool reds, cool yellows, warm blues and warm violets. See the chart below that gives you a few examples of this.

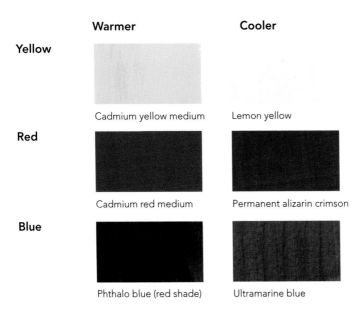

	Warmer	**Cooler**
Yellow	Cadmium yellow medium	Lemon yellow
Red	Cadmium red medium	Permanent alizarin crimson
Blue	Phthalo blue (red shade)	Ultramarine blue

90% of the main colour + 10% of another colour to dull it

When you need to dull or modify a colour such as a bright yellow like cadmium yellow medium, try adding 10% of a blue such as ultramarine. This creates a much more subtle colour than if you use a paint straight from the tube.

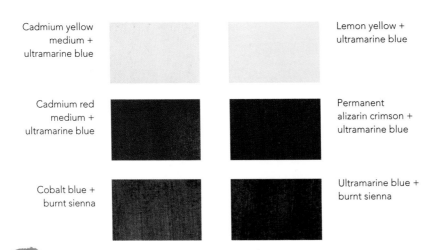

Cadmium yellow medium + ultramarine blue

Lemon yellow + ultramarine blue

Cadmium red medium + ultramarine blue

Permanent alizarin crimson + ultramarine blue

Cobalt blue + burnt sienna

Ultramarine blue + burnt sienna

Creating depth in a painting

To create depth in a painting, you must consider both tone and how warm or cool the colours you are using are. Warm and bright colours should be used in the foreground of a painting, and as the painting recedes, the colours will be paler and slightly bluer (cooler.)

The easiest way to illustrate this is firstly to look at the simple examples below.

Wrong

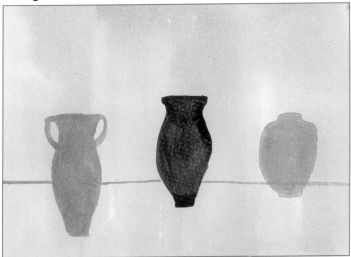

This painting is incorrect as the smaller jar on the right-hand side is supposed to be further back than the two jars on the left. However, as I have painted the right-hand jar a brighter colour, it jumps out, making it appear to be in the foreground.

Right

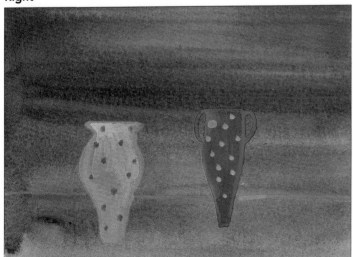

This painting works, as the tones of the jars are similar, with the one on the left, that is further forward, being slightly brighter, so that each jar appears to be in the correct place in the picture.

Try some similar exercises yourself. To make a successful painting, you need the correct tone as well as the right colour.

Colour tone

The tone in a painting is crucial to its success. To begin to assess tone accurately, make tonal colour swatches, as shown here. This is not as easy as it looks, but it is an excellent exercise to help you understand tone.

To start with, choose one colour and gradually add white to make as many tonal swatches as you can. Then you could mix a colour and add white in the same way to see how many different tones of this mix you can make.

Ultramarine blue + white: twelve mixes to gradually lighten the blue. Try this exercise yourself.

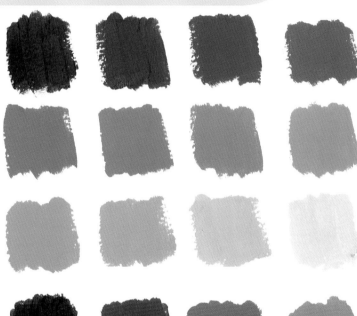

80% ultramarine blue + 20% cadmium yellow medium with white progressively added

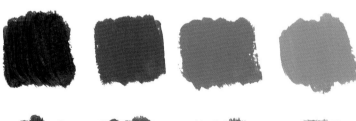

80% permanent rose + 20% lemon yellow with white progressively added

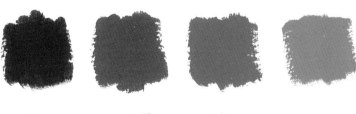

80% cadmium orange + 20% ultramarine blue with white progressively added

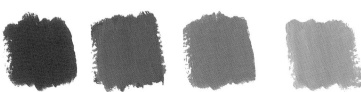

Ultramarine
blue with white
progressively added

50% ultramarine
blue + 50% burnt
sienna with white
progressively added

Red iron oxide with white
progressively added

50% red iron oxide
+ 50% cobalt blue
with white
progressively added

Permanent rose with
white progressively added

80% phthalo blue (red
shade) + 20% lemon
yellow with white
progressively added

80% cadmium
orange + 20% lemon
yellow with white
progressively added

21

Using a limited palette

Painting with a limited palette has the advantage of creating harmony in your work. It also means that you will have to work harder to mix the colours that you need but this means that you will also learn a great deal about colour on the way!

If you try this you will be amazed at just how many colours you can create from only one red, one yellow and one blue. The charts below illustrate this for you and these charts do not include tonal variations of each mix so the possibilities are almost endless. Working with one red, one blue and one yellow I have created charts for you to use. The charts work as follows:

1 Pure colour
2 Colour + 10% of next colour
3 Colour + 20%
4 Colour + 30%
5 Colour + 40%

6 Colour + 50%
7 Colour + 60%
8 Colour + 70%
9 Colour + 80%
10 Pure colour

Phthalo blue (red shade) + permanent rose

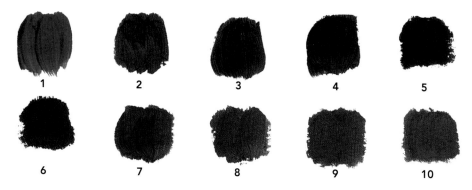

Permanent rose + cadmium yellow medium

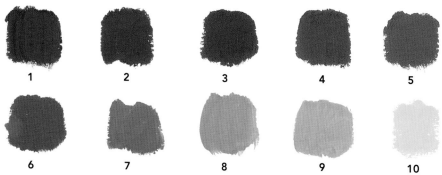

22

Cobalt blue + permanent rose

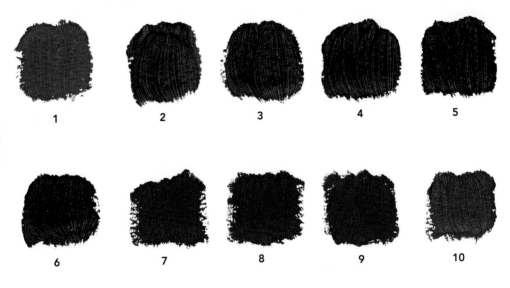

1

2

3

4

5

6

7

8

9

10

Lemon yellow + permanent rose

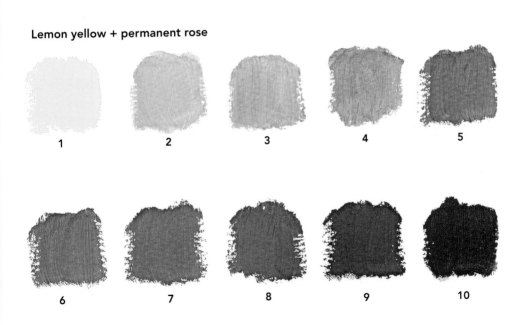

1

2

3

4

5

6

7

8

9

10

Phthalo blue (red shade) + cadmium yellow medium

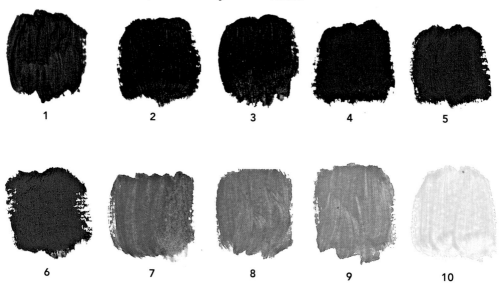

1 2 3 4 5

6 7 8 9 10

Cadmium red medium + cadmium yellow medium

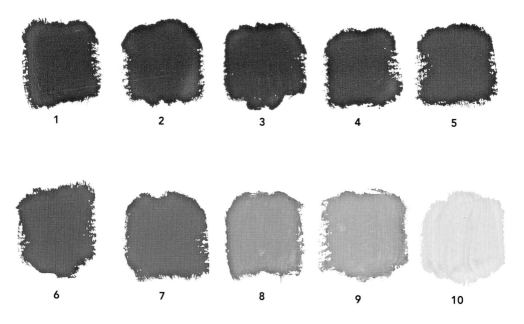

1 2 3 4 5

6 7 8 9 10

Cobalt blue + cadmium red medium

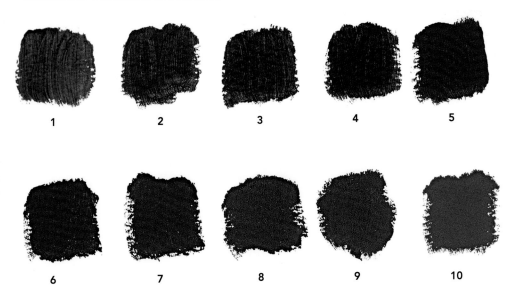

1 2 3 4 5

6 7 8 9 10

Cadmium red medium + lemon yellow

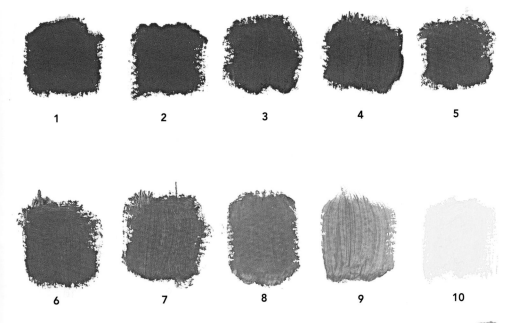

1 2 3 4 5

6 7 8 9 10

Dull and bright colours

When we refer to 'dull' colours, we really mean 'less bright'. When we refer to 'bright' colours, we must remember that the brightest colours are the pure pigments that come straight from the tube, and we can't make these colours any brighter. But we can dull them. We may be tempted to use black to dull down a colour, but black will deaden colours. It is better to darken a colour by adding the opposite colour in the spectrum, e.g. we can add blue or violet to yellow-green or yellow-orange mixtures. This will dull the colour as if it is in shadow, but it will still be colourful. See the examples below and then see if you can think of some of your own.

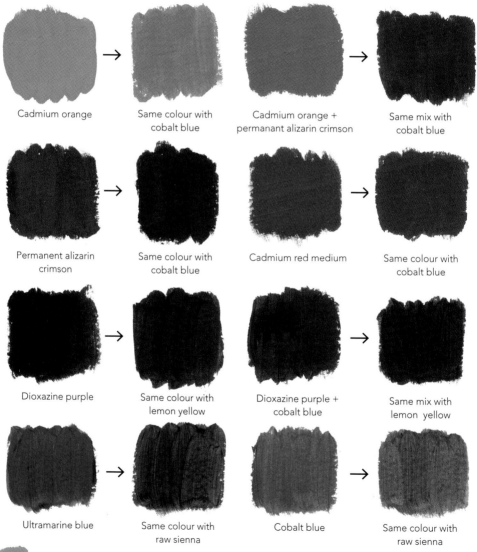

Cadmium orange	Same colour with cobalt blue	Cadmium orange + permanant alizarin crimson	Same mix with cobalt blue
Permanent alizarin crimson	Same colour with cobalt blue	Cadmium red medium	Same colour with cobalt blue
Dioxazine purple	Same colour with lemon yellow	Dioxazine purple + cobalt blue	Same mix with lemon yellow
Ultramarine blue	Same colour with raw sienna	Cobalt blue	Same colour with raw sienna

Local colour

To make the most of the colours in your paintings you always need to consider the 'relationships' of the colours used. Notice in the simple examples below how a colour will appear to be completely different when placed next to another colour – it may appear brighter, lighter, darker or cooler depending where it is in your picture.

Cadmium orange with ultramarine blue

... with cobalt blue

... with dioxazine purple

Permanent alizarin crimson with ultramarine blue

...with cobalt blue

...with cadmium orange

Raw sienna with phthalo blue (red shade)

...with cobalt blue

...with dioxazine purple

Burnt sienna with phthalo blue (red shade)

...with cobalt blue

...with dioxazine purple

Permanent rose with lemon yellow

...with raw sienna

...with cadmium yellow medium

Colour mixes

The next part of this book is dedicated to colour mixing in the following format: start with one pure colour, then add 20% of another colour, then add 40%, then add 60%, lastly add 80%.

Yellows and oranges

Lemon yellow + cadmium yellow medium

+ raw sienna

+ cadmium orange

50/50 lemon yellow + cadmium yellow medium + water

Cadmium yellow medium

+ red iron oxide

+ burnt sienna

50/50 cadmium yellow medium + burnt sienna

+ water

Raw sienna

+ red iron oxide

+ cadmium red medium

+ burnt sienna

50/50 raw sienna + cadmium red medium

+ water

Cadmium orange

+ permanent rose

 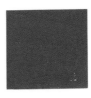

+ permanent alizarin crimson

+ cadmium red medium

50/50 cadmium orange + permament rose

+ water

Reds and pinks

Cadmium red medium + phthalo blue (red shade)

+ dioxazine purple

+ permanent rose

50/50 permanent rose + cadmium red medium + white

Permanent rose

+ cadmium orange

+ permanent alizarin crimson

+ dioxazine purple

50/50 dioxazine purple + permanent rose

+ white

Permanent alizarin crimson

+ cadmium red medium

+ dioxazine purple

+ phthalo blue (red shade)

50/50 cadmium red medium + permanent alizarin crimson

+ white

Red iron oxide

+ cadmium red medium

+ permanent rose

+ permanent alizarin crimson

50/50 permanent alizarin crimson + red iron oxide

+ white

Violets and blues

Ultramarine blue

+ phthalo blue (red shade)

+ permanent alizarin crimson

50/50 ultramarine + cobalt blue
+ white

Cobalt blue

+ permanent alizarin crimson

+ permanent rose

+ cadmium red medium

50/50 cobalt blue + permanent rose

+ white

Phthalo blue (red shade)

+ permanent rose

+ permanent alizarin crimson

+ cadmium red medium

50/50 phthalo blue red shade + cadmium red medium

+ white

Dioxazine purple

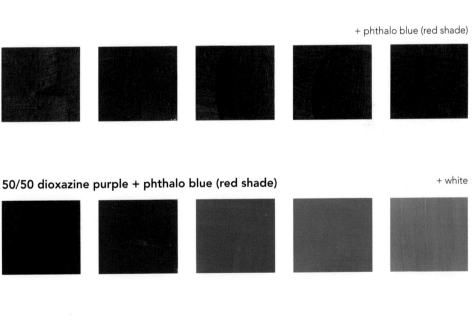

+ ultramarine blue

+ phthalo blue (red shade)

50/50 dioxazine purple + phthalo blue (red shade)

+ white

Greens

Ultramarine blue

+ cadmium yellow medium

+ lemon yellow

50/50 ultramarine blue + lemon yellow

+ white

Phthalo blue (red shade)

+ raw sienna

+ cadmium yellow medium

+ lemon yellow

50/50 phthalo blue (red shade) + lemon yellow

+ white

41

Cobalt blue

+ cadmium yellow medium

+ lemon yellow

50/50 cobalt blue + lemon yellow

+ white

Cadmium yellow medium + a touch of phthalo blue (red shade) + a touch of white

50/50 cadmium yellow medium + phthalo blue (red shade) + a touch of white

25% cadmium yellow medium + 75% phthalo blue (red shade) + a touch of white

Phthalo blue (red shade) + a touch of cadmium yellow medium + a touch of white

Raw sienna + a touch of phthalo blue (red shade) + a touch of white

50/50 raw sienna + phthalo blue (red shade) + a touch of white

25% raw sienna + 75% phthalo blue (red shade) + a touch of white

Phthalo blue (red shade) + a touch of raw sienna + a touch of white

50/50 ultramarine blue + burnt sienna

...with a touch of cadmium yellow medium

...with a bit more cadmium yellow medium

...with a bit more cadmium yellow medium

...with a bit more cadmium yellow medium

25% ultramarine blue + 75% burnt sienna

...with a touch of lemon yellow

...with a bit more lemon yellow

...with a bit more lemon yellow

...with a bit more lemon yellow

Browns

Burnt sienna

+ dioxazine purple

+ red iron oxide

+ raw sienna

+ lemon yellow

Red iron oxide

50/50 red iron oxide + burnt sienna

Blacks and greys

Burnt sienna
+ ultramarine blue

+ cobalt blue

20% burnt sienna + 80% ultramarine blue
+ white

20% burnt sienna + 80% cobalt blue
+ white

Phthalo blue (red shade)

+ burnt sienna

20% phthalo blue (red shade) + 80% burnt sienna

+ cobalt blue

Equal parts ultramarine blue + raw sienna + burnt sienna

+ white

Equal parts cobalt blue + raw sienna + burnt sienna

+ white

Glossary

All of these terms are explained in the context of acrylic painting.

Acrylic medium This can be mixed with the acrylic paint to alter the texture. Types include gloss, matt, heavy body and iridescent.

Acrylic sheets, pads and blocks Various forms of textured paper suitable for acrylics.

Artists' (professional) range The highest quality paints with the purest pigments.

Bristle brush A coarse-textured brush made from bristle.

Canvas Cotton or linen fabric surface which needs to be primed ready to use for acrylic painting.

Canvas boards Canvas stretched over a frame or glued to to a board and and primed ready for acrylic painting.

Colour wheel A wheel that includes the three primary, three secondary and six tertiary colours. Essential to understanding colour mixing (see page 10).

Extender A medium that can be added to acrylic paint to extend (increase) the amount of paint.

Filbert A narrow, flat brush with a rounded tip.

Flat brush A brush with a flat or square end.

Impasto A painting technique in oils or acrylics where paint is laid on very thickly and brush or knife strokes are visible.

Local colour How one colour affects another in a picture or particular context.

Opaque A non-transparent colour, where paint does not allow the white of the paper or canvas to shine through.

Palette The surface on which you lay out and mix your colours, which can be disposable paper sheets, wood, glass, clear acrylic or plastic, with stay-wet options.

Permanent A light-fast colour that does not fade, e.g. permanent alizarin crimson. The old alizarin crimson could fade in daylight.

Phthalocyanine An intensely blue-green coloured compound used in dyeing and making colours such as phthalo blue (red shade).

Primed Treated with a coat of white acrylic primer to protect the canvas prior to painting with acrylic paints.

Quinacridone A high performance, synthetic pigment.

Round brush A brush with a round shape and a point.

Single pigment Paint made from one pure pigment.

Spectrum The range of colours the human eye can see, as in a rainbow.

Staining This type of paint will stain the paper (or your clothes) and cannot be removed.

Students' range Lower quality than artists' range paints, but still good and more affordable.

Synthetic brush Made from acrylic or synthetic material.

Tone How light or dark a colour is.

Transparent Paint that you can see through, allowing the white of the paper or canvas to shine through.